A Classic Illustrated Treasury

HORSES

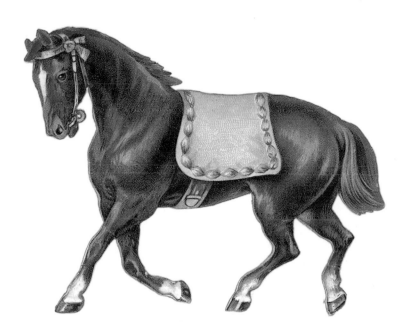

PAVILION

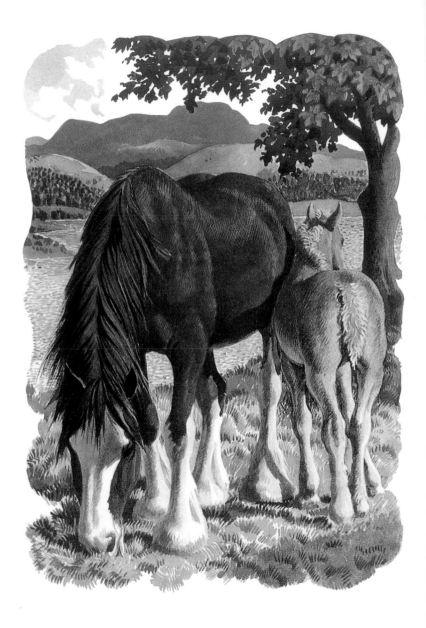

PICTURE CREDITS:
Cover: *George Stubbs, 1910's;* Title Page: *Anonymous, 1910's;*
facing the Table of Contents: *C. F. Tuncliffe, 1949;*
Back Cover: *Anonymous, 1938*

ACKNOWLEDGEMENTS

We thank the following for permission to use these poems:
"White Horses," from *Over the Garden Wall,* by Eleanor
Farjeon. Copyright 1933, 1961 by Eleanor Farjeon. Selection
reprinted by permission of HarperCollins Publishers.
Reprinted by permission of David Hingham Associates Ltd.
Houghton Mifflin Company for "The War God's Horse
Song," translated from the Navajo by Dane and Mary
Roberts Coolidge, from *The Navajo Indian.* "Circus Caval-
cade," from *A World to Know,* by James S. Tippett. Copyright
1933 by Harper & Row. Renewed 1961 by Martha Tippett.
Selection reprinted by permission of HarperCollins Pub-
lishers. Reprinted by permission of Macmillan Publishing
Company "Equestrienne," by Rachel Field, from *Poems,*
copyright 1934 by Macmillan Publishing Company.
Renewed 1962 by Arthur S. Pederson. "Riding Lesson"
Copyright 1975 by Henry Taylor. Reprinted from *An After-
noon of Pocket Billiards* (University of Utah Press 1975) by per-
mission of the author.

Table of Contents

White Horses *by Eleanor Farjeon*

Saddle Song *anonymous*

Children's Rhyme *anonymous*

The New Born Colt *by Mary Kennedy*

The War God's Horse Song *translated from the Navajo by Dane and Mary Roberts Coolidge*

from Wild Horses *by Mary Crow*

Round-Hoof'd *by William Shakespeare*

Catching the Horse *by Barbara Winder*

Circus Parade *by James S. Tippett*

Equestrienne *by Rachel Field*

The Stallion *by Walt Whitman*

Riding Lesson *by Henry Taylor*

The Kentucky Thoroughbred *by James Whitcomb Riley*

My Pony *by "A"*

The Fly-Away Horse *by Eugene Field*

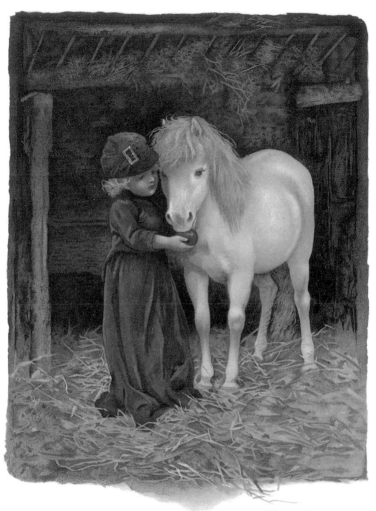

−Harriet Bennett, 1893

WHITE HORSES

Count the white horses you meet on the way,
Count the white horses, child, day after day,
Keep a wish ready for wishing–if you
Wish on the ninth horse, your wish will come true.

I saw a white horse at the end of the lane,
I saw a white horse canter down by the shore,
I saw a white horse that was drawing a wain,
And one drinking out of a trough: that made four.

I saw a white horse gallop over the down,
I saw a white horse looking over a gate,
I saw a white horse on the way into town,
And one on the way coming back: that made eight.

But oh for the ninth one: where *he* tossed his mane,
And cantered and galloped and whinnied and swished
His silky white tail, I went looking in vain,
And the wish I had ready could never be wished.

Count the white horses you meet on the way,
Count the white horses, child, day after day,
Keep a wish ready for wishing–if you
Wish on the ninth horse, your wish will come true.

–*Eleanor Farjeon*

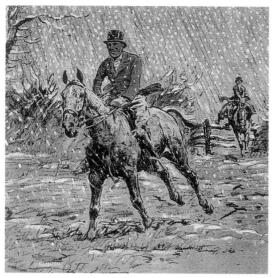

—Snaffles, 1930's

SADDLE SONG

Take the life of cities!
Here's the life for me.
'T were a thousand pities
Not to gallop free.
So we'll ride together,
Comrade, you and I,
Careless of the weather,
Letting care go by.

—*Anonymous*

CHILDREN'S RHYME

Up the hill,
Hurry me not;
Down the hill,
Worry me not;
On the level,
Spare me not;
In the stable,
Forget me not.

–Anonymous

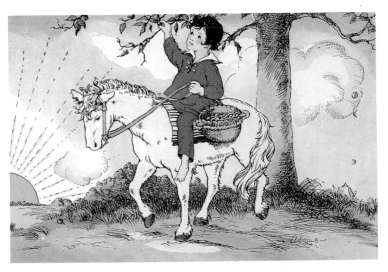

–Pauline Adams, 1929

THE NEW BORN COLT

It dances –
The muscles slipping freely
Beneath the fine skin,
The small joints miracles of perfection.
In confident awareness,
In the pride of being alive,
It lifts with grace the pointed white hooves.
Between the foal and its mother is a great love.
It moves with her almost as one,
Yet in no way bound,
While every upright shining hair
On its short ruffle of a mane,
Dances with joy.

–Mary Kennedy

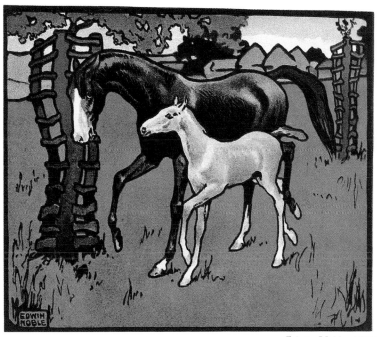

—*Edwin Noble, 1909*

THE WAR GOD'S HORSE SONG

I am the Turquoise Woman's son
On top of Belted Mountain
Beautiful horses—slim like a weasel!
My horse has a foot like striped agate;
His fetlock is like a fine eagle plume;
His legs are like quick lightning.
My horse's body is like an eagle-plumed arrow;
My horse has a tail like a trailing black cloud.
I put flexible goods on my horse's back;
The Little Holy Wind blows through his hair.

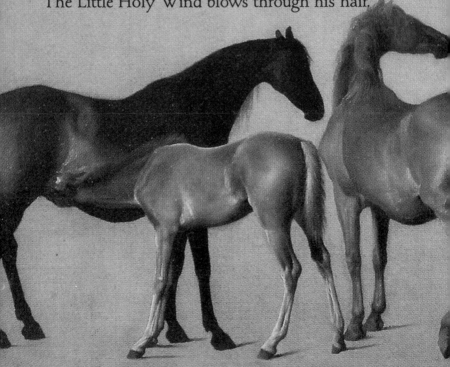

His mane is made of short rainbows.
My horse's ears are made of round corn.
My horse's eyes are made of big stars.
My horse's head is made of mixed waters
 (From the holy waters—he never knows thirst)
My horse's teeth are made of white shell.
The long rainbow is in his mouth for a bridle,
 And with it I guide him.
When my horse neighs, different colored horses follow.

—Translated from the Navajo by
Dane and Mary Roberts Coolidge

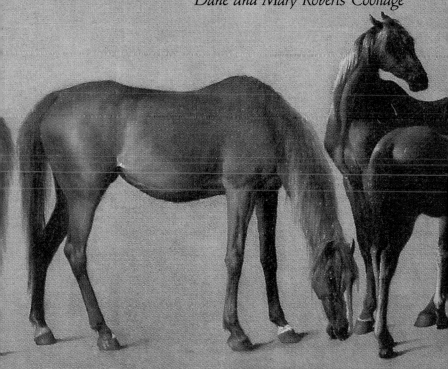

—George Stubbs, 1762

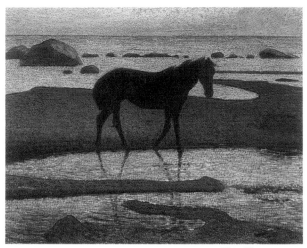

–Nils Kreuger, 1902

from WILD HORSES

But every night now
for a month
I have run away
to the blue lake
where the wild horses
come to drink . . .

. . . In the moonlight
the white coats are blue
and the bays are shadows.
I stand perfectly still.
My legs grow long and powerful.
I will run with the horses.

–Mary Crow

ROUND-HOOF'D

Round-hoof'd, short-jointed, fetlocks shag and long,
 Broad breast, full eye, small head, and nostril wide,
High crest, short ears, straight legs and passing strong,
 Thin mane, thick tail, broad buttock, tender hide:
Look, what a horse should have he did not lack,
Save a proud rider on so proud a back.

–William Shakespeare

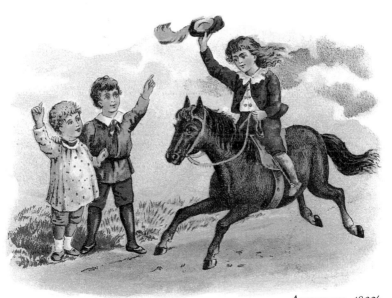

–Anonymous, 1890's

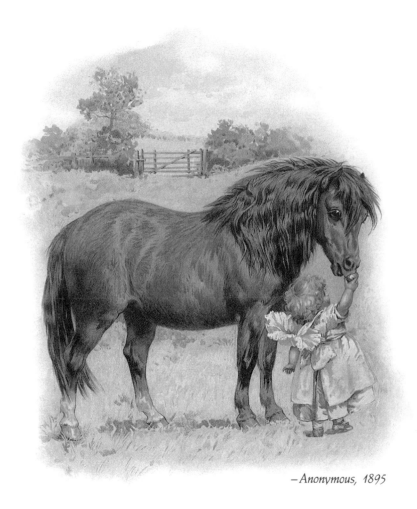

—*Anonymous, 1895*

CATCHING THE HORSE

When you get out there
holding the rope and the halter
and the carrots
as casually as you can,
remember that she'll
outrun you at a trot,
so don't rush right up
to her silk flanks

quivering. Then give her
another carrot and slip
the halter over her nose
while she's still chewing,
clipping the rope
under her chin so you
won't have to dig in
with your heels or start
all over again in another
part of the pasture.

Now start whistling
and lead her into
the barn.

—Barbara Winder

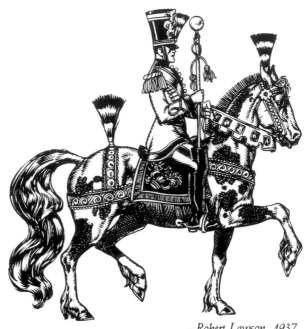

–Robert Lawson, 1937

CIRCUS PARADE

Gaily plumed a horse and rider
Lead the circus cavalcade.

–James S. Tippett

EQUESTRIENNE

Her spangles twinkle; his pale flanks shine,
Every hair of his tail is fine
And bright as a comet's; his mane blows free,
And she points a toe and bends a knee,
And while his hoofbeats fall like rain
Over and over and over again.

–Rachel Field

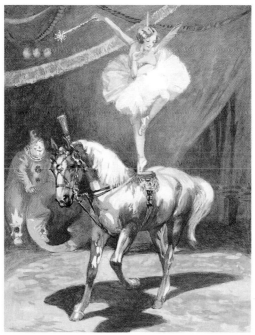

–Honor Appleton, 1930

THE STALLION

A gigantic beauty of a stallion,
 fresh and responsive to my caresses,
Head high in the forehead
 and wide between the ears,
Limbs glossy and supple,
 tail dusting the ground,
Eyes well apart and full of sparkling wickedness
 . . . ears finely cut and flexibly moving.

–Walt Whitman

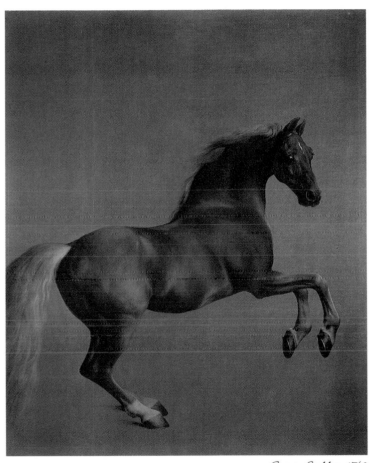

—George Stubbs, 1762

RIDING LESSON

I learned two things
from an early riding teacher.
He held a nervous filly
in one hand and gestured
with the other, saying, "listen.
Keep one leg on one side,
the other leg on the other side,
and your mind in the middle."

–Henry Taylor

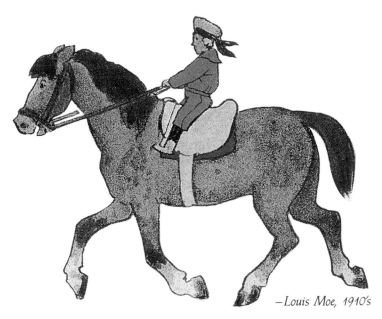

–Louis Moe, 1910's

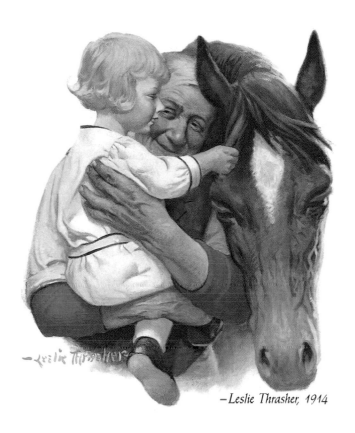

−Leslie Thrasher, 1914

THE KENTUCKY THOROUGHBRED

I love the hoss from hoof to head,
From head to hoof and tail to mane;
I love the hoss, as I have said,
From head to hoof and back again.

−*James Whitcomb Riley*

MY PONY

How charming it would be to rear,
 And have hind legs to balance on;
Of hay and oats within a year
 To leisurely devour a ton;
To stoop my head and quench my drouth
 With water in a lovely pail;
To wear a snaffle in my mouth,
 Fling back my ears, and slash my tail!

– "A."

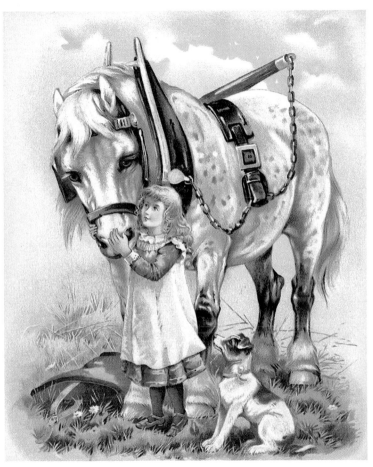

–R. J. Wealthy, 1890's

THE FLY-AWAY HORSE

Oh, a wonderful horse is the Fly-Away Horse—
 Perhaps you have seen him before;
Perhaps, while you slept, his shadow has swept
 Through the moonlight that floats on the floor.
For it's only at night, when the stars twinkle bright,
 That the Fly-Away Horse, with a neigh
And a pull at his rein and a toss of his mane,
 Is up on his heels and away!
 The Moon in the sky,
 As he gallopeth by,
 Cries: "Oh! what a marvellous sight!"
 And the Stars in dismay
 Hide their faces away
 In the lap of old Grandmother Night.

<div align="right">

—Eugene Field

</div>

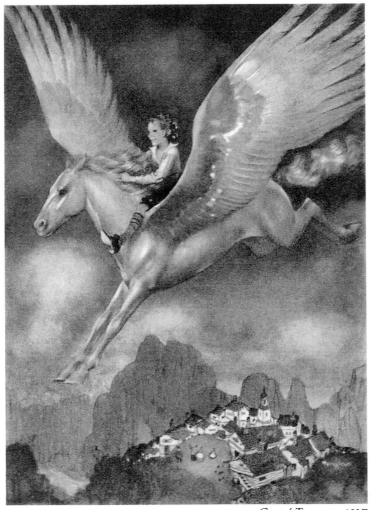

-Gustaf Tenggren, 1927